T0054433

Fur Coats & Backpacks

Fur Coats & Backpacks
The Travel Cats Hit the Road

Artwork & Cat Poems
by Mari Ichimasu

Chin Music Press | Summer 2022

Chin Music Press
1501 Pike Place #329
Seattle, WA 98101
USA
www.chinmusicpress.com

Book design by Jackie Carberry & Carla Girard
Printed in the USA
Library of Congress Control Number: 2020940636

FOR ALL THE TRAVELING SOULS

Table of Contents

INTRODUCTION

Everyone is on their own journey
Light a small lantern,
Let me hear your story tonight

Jackie

Early spring on a mountain
Here comes Jackie
Taking a walk on a wild animal passage

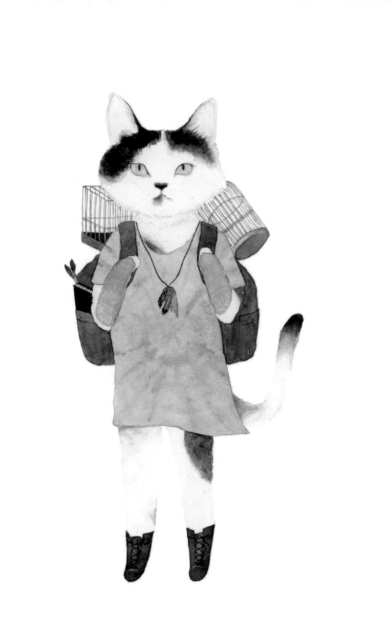

Jackson

Panorama of the vast sky
with countless stars on a mountaintop
Jackson makes pancakes for breakfast

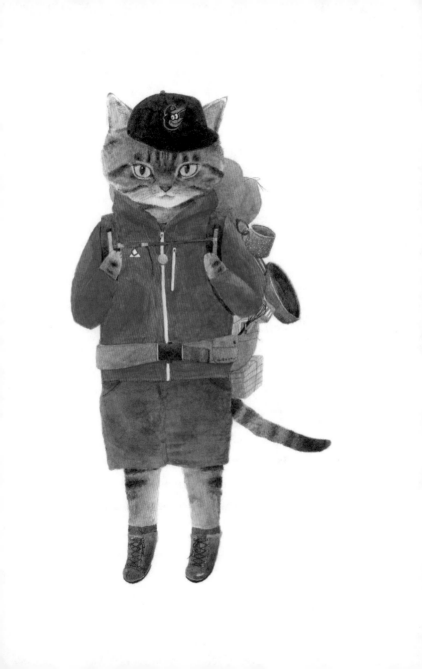

Yuzu

A warm bright moonlit night
Yuzu aims for a secret grassland
spreading far away between mountains

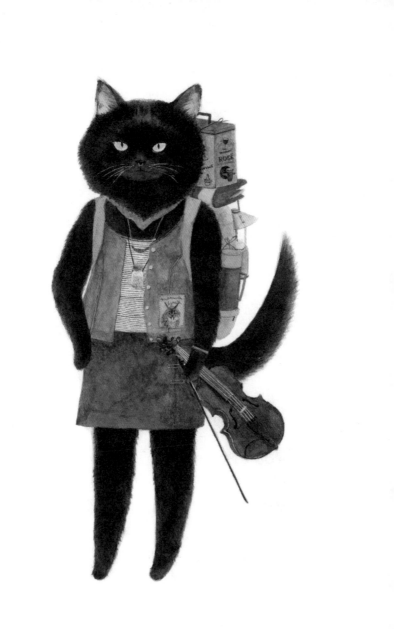

Figaro

Some days the urge hits
To leave the comfort of a warm bed
and wander

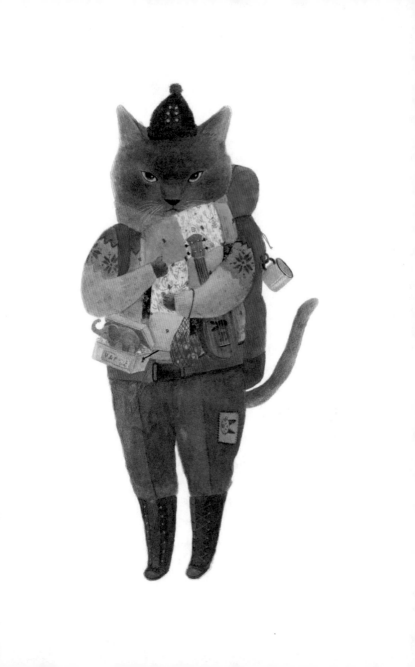

Lucy

The universe spreads out to infinity
Even in a small wildflower
Once Lucy taught me

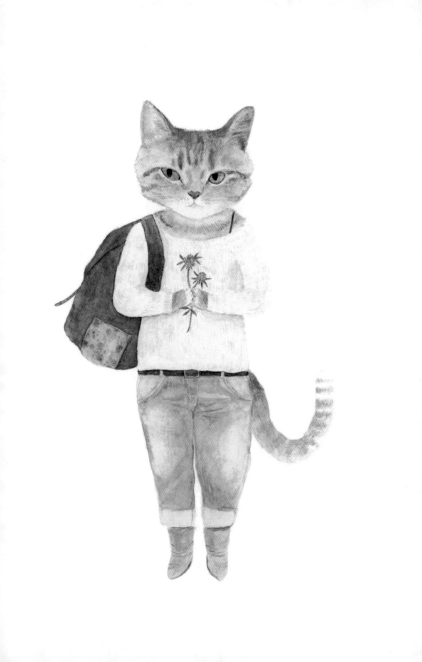

Arnold

It is a clear night on top of the hill
Arnold brings his friends
For a meteor shower show

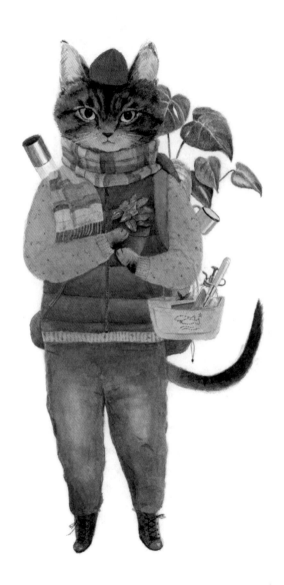

Monster

During a sudden spring rain
A feathery neighbor stops by
Trading herbal secrets together

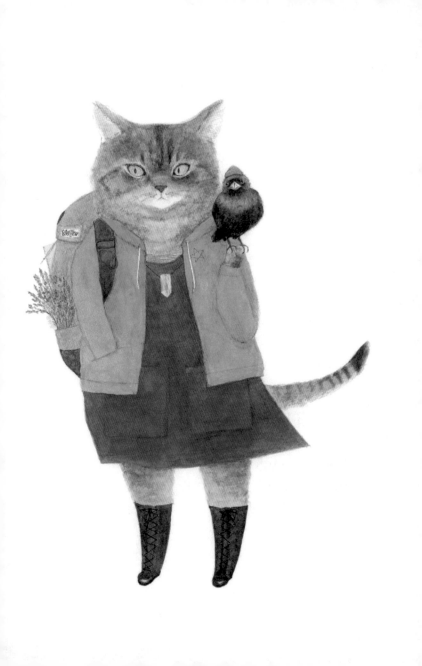

Beau

Someone told me that
Beau will be back soon
Just can't wait!

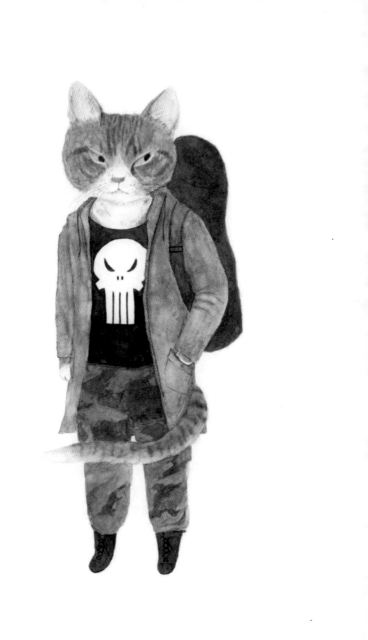

Jake

Once departed
The unknown
becomes clear

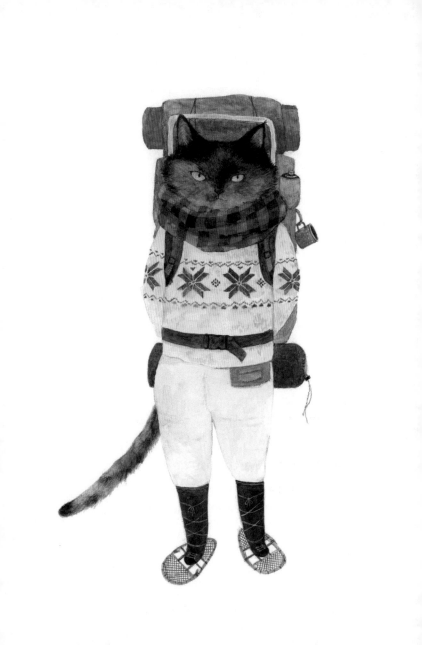

Leo

Awoken by Earth's pulse
Enchanted by the sunshine
Leo closes his eyes again

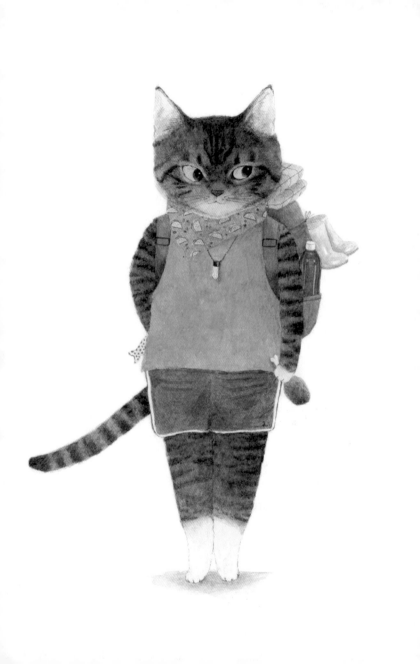

Eliza

Plum blossoms bloom
In the Kuwabata family garden
Spring is surely coming

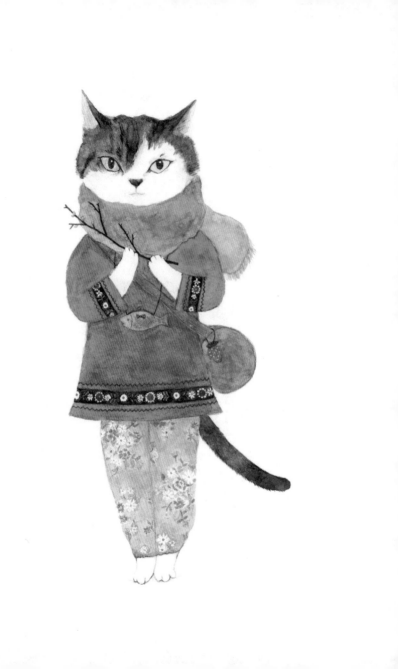

Ludwig

Sunrise will come soon
Let's stay a little longer
Ludwig pours another glass of red wine

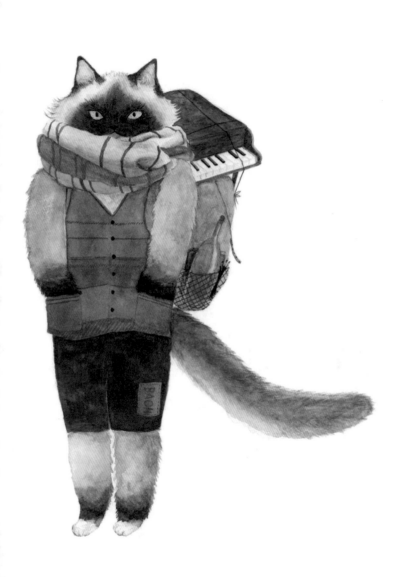

Daniela

The infinite expanse
From Daniela's journal
Colorful wind rises
She goes deeper

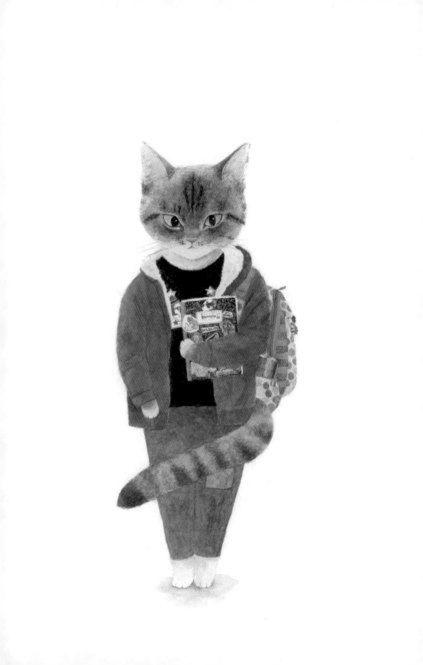

Hey! Zeus

A summer picnic in the grass
Layers of bento boxes & happy hour drinks.
¿Por qué no?

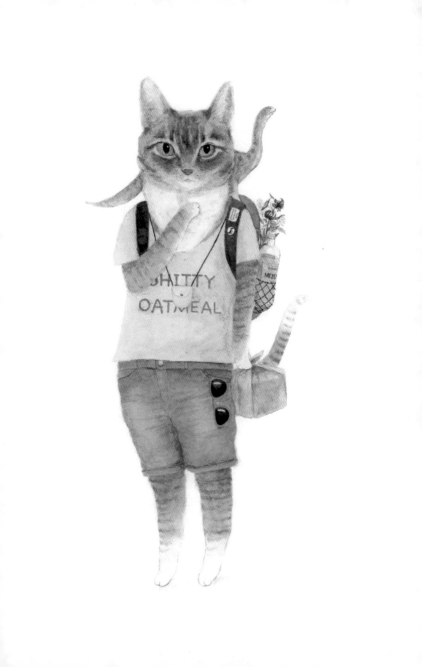

Travis

Looking for his soul music
North to south
East to west
Travis keeps on traveling

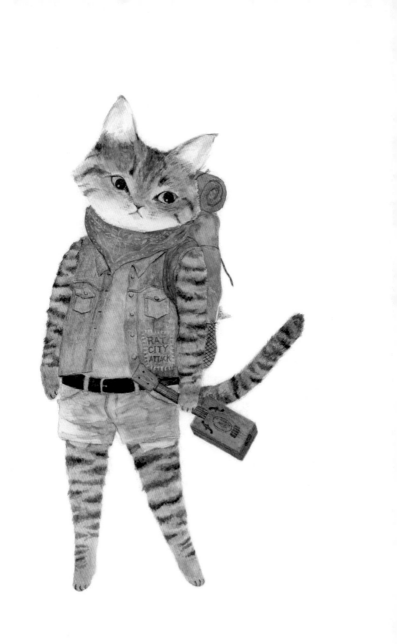

Keisha

The radio plays a tune
On a summer evening walk
It's sunset

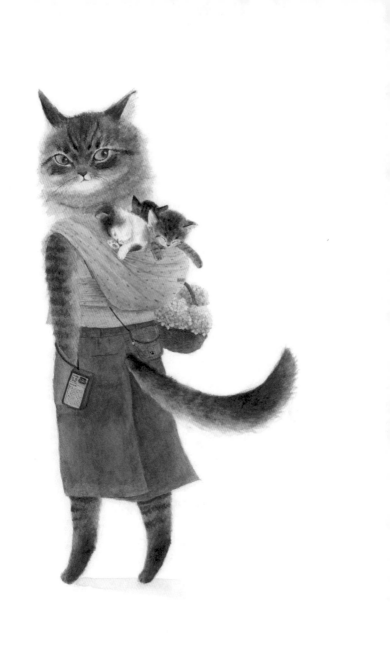

Jack

Arriving at the beach
Crashing waves come and go
Jack looks for sea glass

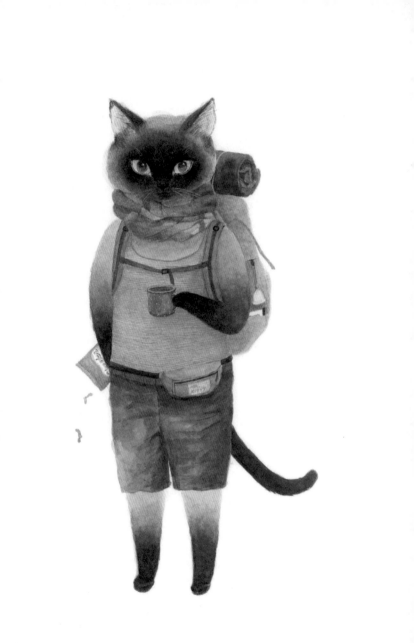

Wiley

Darting in the night
Soon I will be out in the open
A new chapter begins

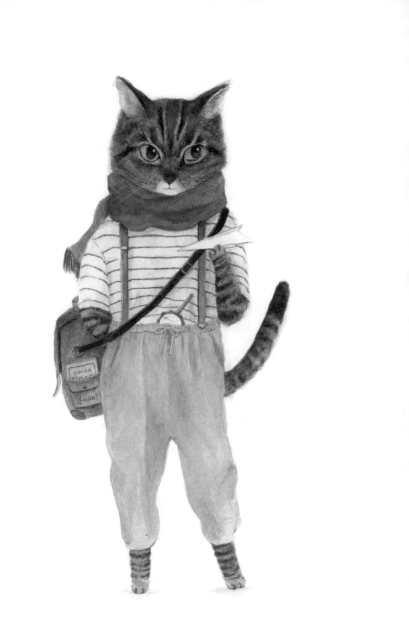

Chowder

Knowledge opens doors
On a hot summer day
Chowder reads the secrets of space
Under a shady tree

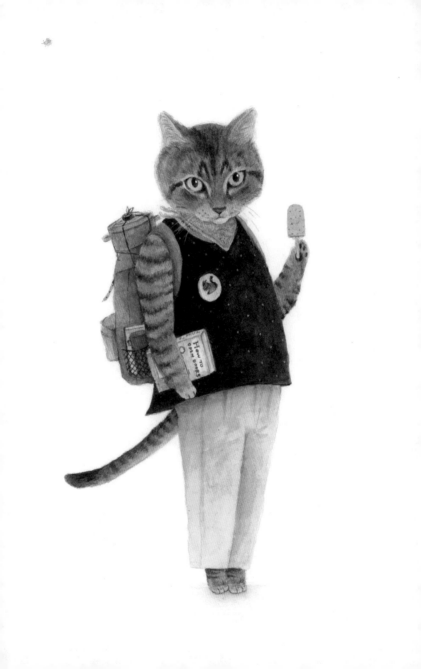

Shiro

On a sparkly sand dune
the wind whistles by
gifting Shiro a tune

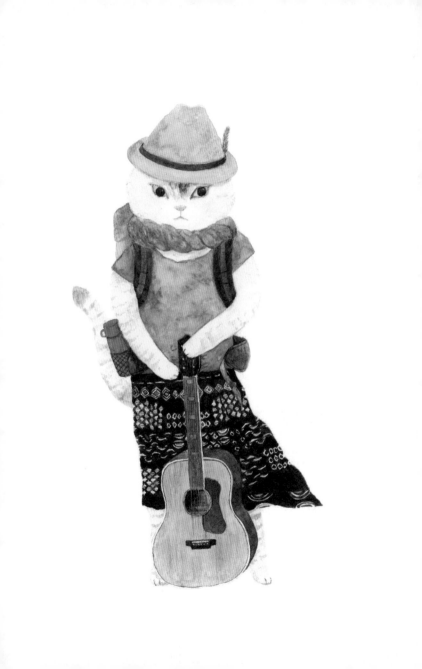

Peanut

In an orange poppy field
Peanut is still
Ready to pounce on this bee

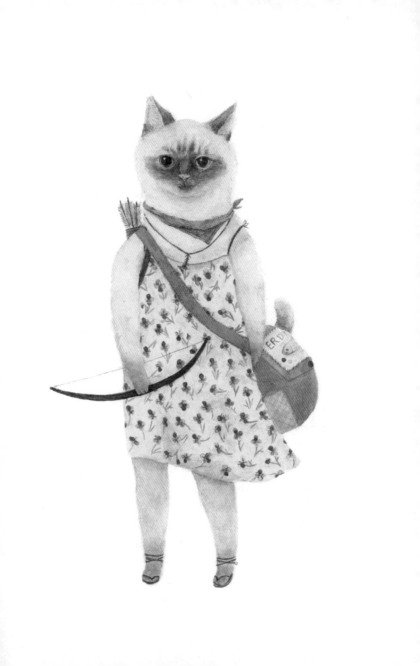

Zim

Early summer morning
Before anyone is up
Zim is on purple clouds,
Surfing from dream to dream

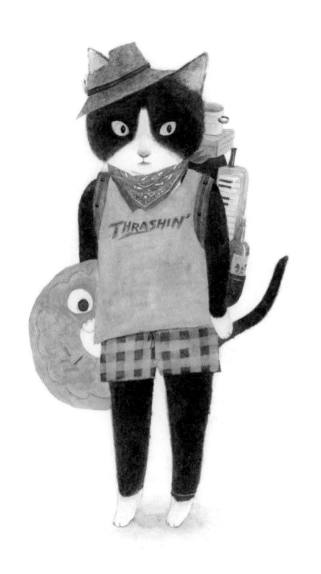

Vivian

Skirt? Pleated.
Fish? Medium rare.
That's Vivian.

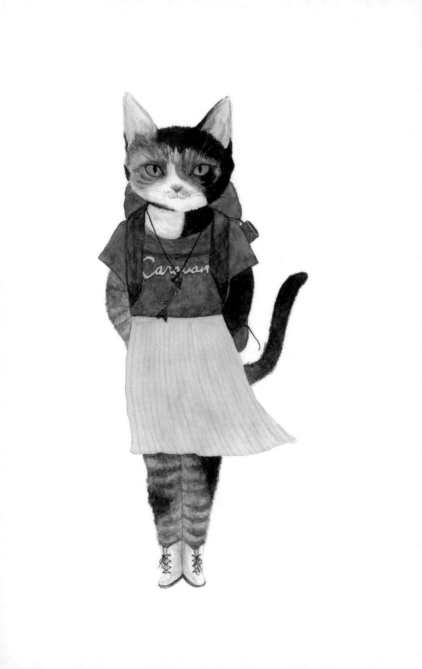

Coconut

Fish bones and Snake River wine
Coco is on a solo trip
with her new songs

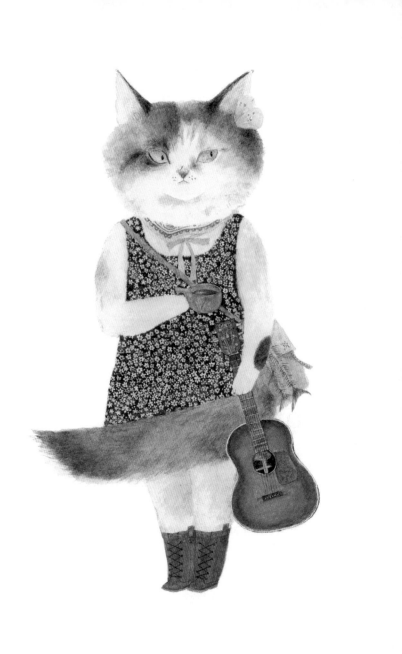

Donovan

On the river
One spring afternoon
Donovan whistles
Waiting for rainbow trout

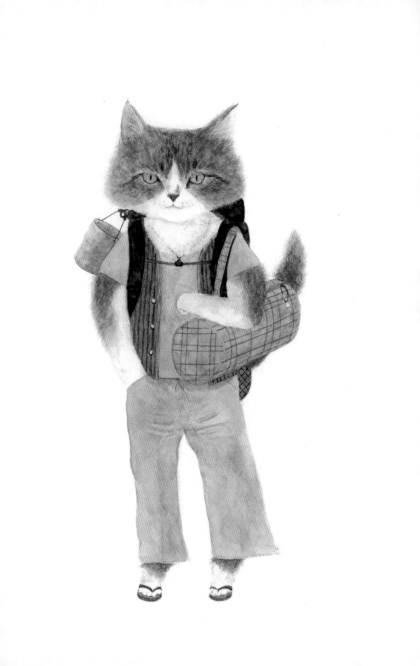

Frankie

The wind in my fur
As fast as fast can be
Later, dudes!

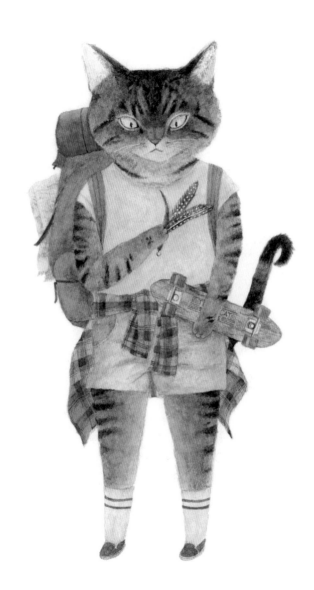

José & Veronica

Morning sun rises
As golden lights radiate, their noses wiggle
The scent of the new beginnings

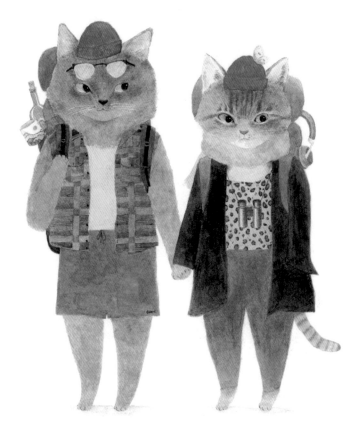

Joey

Butterflies flutter
while Joey stares at ants and slugs
A spring garden kingdom
His tail swings in elation

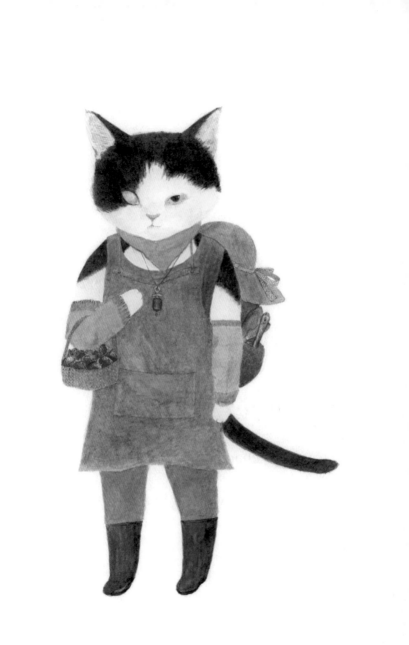

Spencer

Leaves are changing colors
On a day in fall
Spencer quietly walks into a scene
with his sketchbook

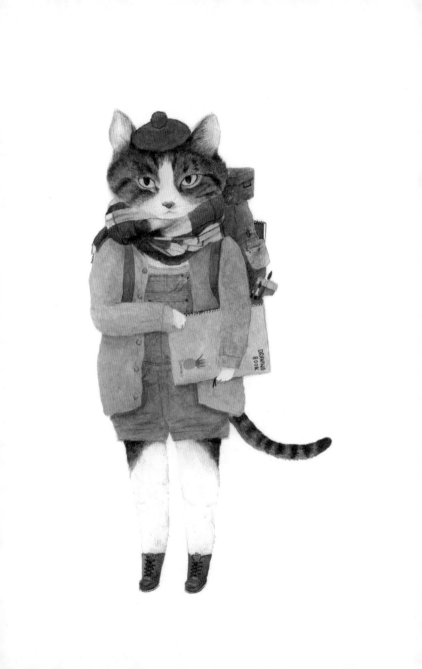

Chaos

A sudden sun shower
in a bright sky
Chaos goes outside to
collect rainbows

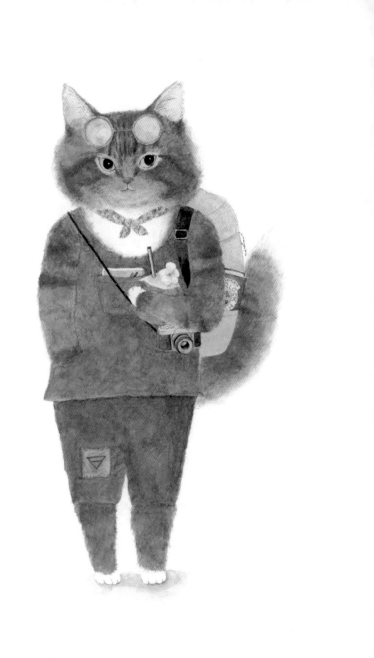

Scoot

The fanfare from Scoot's trumpet
echoes throughout the valley
A lone turtledove sings back

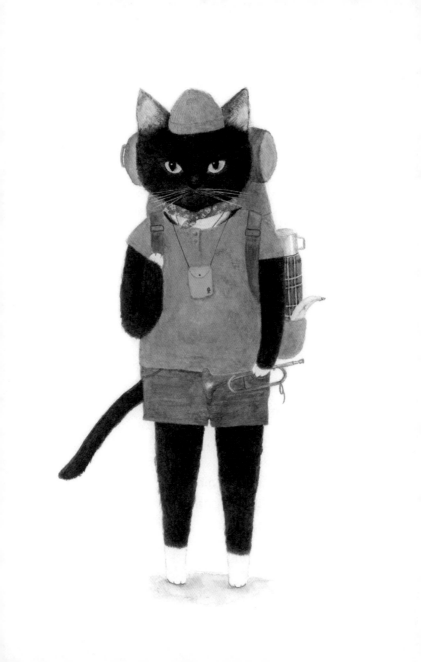

Mishka

In a log cabin
On a snowy mountain
Mishka sips hot cocoa
Before his departure

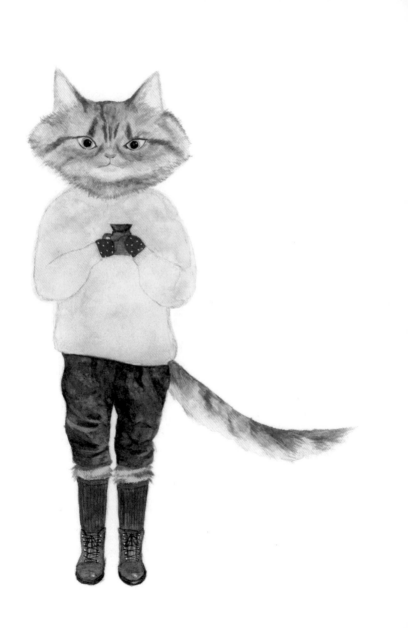

Viola

What do whale songs sound like?
Mist of the rain in early morning
Viola departs north alone

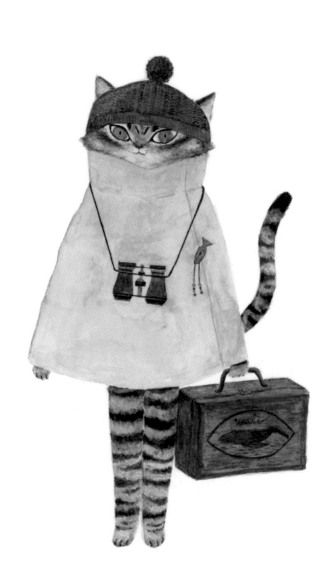

Maka

Blown in the silky wind
Where shall we go today?
When I finally got it,
Maka had already departed

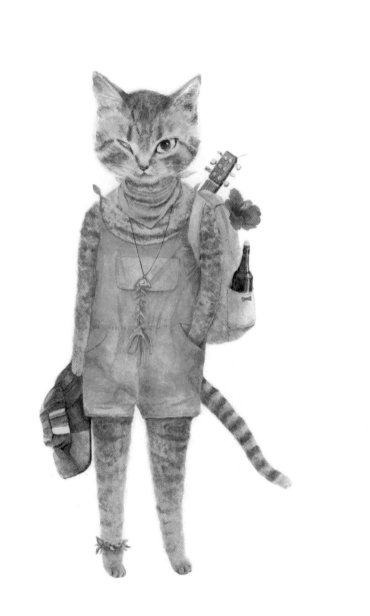

Orion

The river keeps on flowing
Orion is determined
Paddling the current

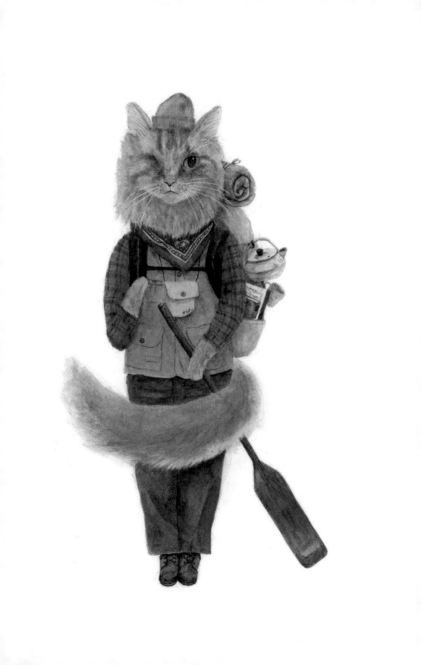

Olivia

A lost lake in the Northwest forest
Fresh spring water reflects cumulus clouds
Olivia is back home

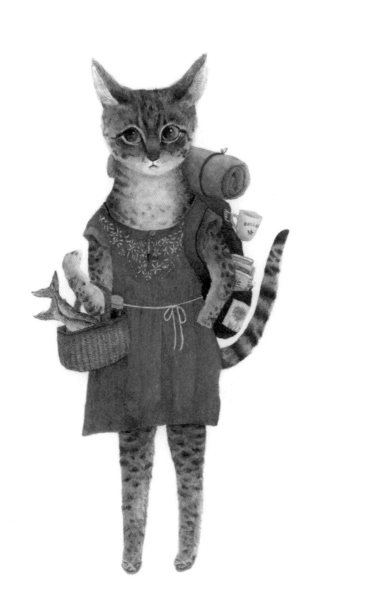

Kira & Francis

Two sparkling drops
Headed to the Tetons

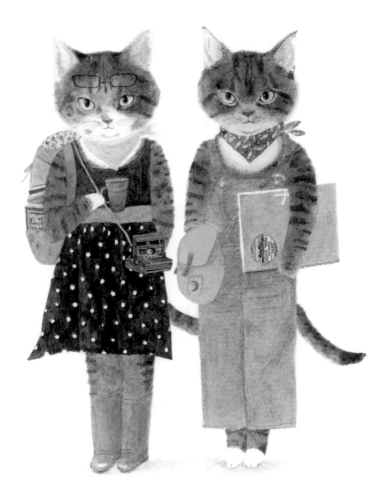

Moonbeam & Leroy

Traveling companions
The moon and the sun
A magical twilight together

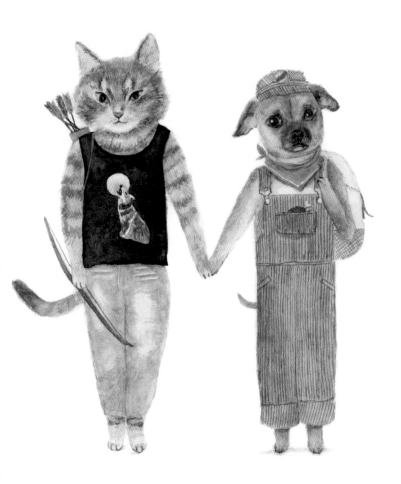

Moose

On a faraway beach
Moose listens to another feather
Each one sings a different story

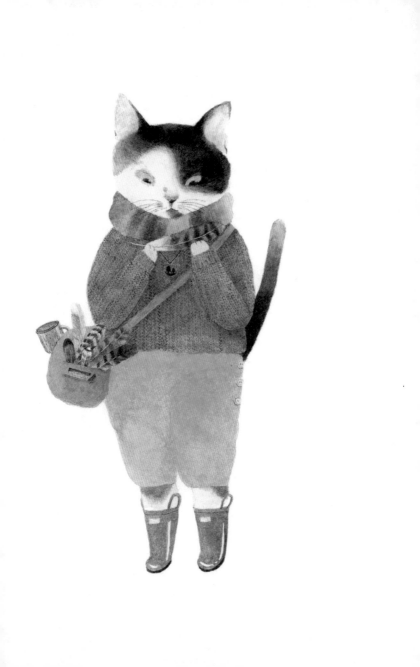

Maki

A message from Earth
the Mother tree calls
as Maki hikes into the forest

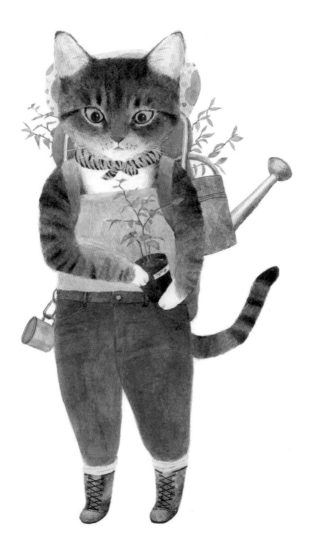

Momo

Fierce Momo on her psychic journey
Walking through the tall grass of a wind tunnel
Crows watch over the salmon pink sky
They got her back

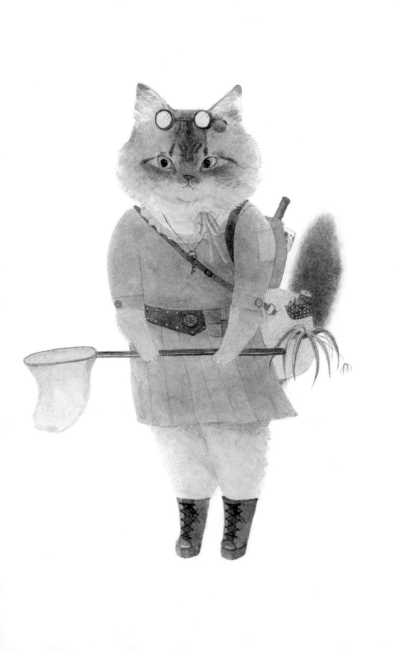

Ziggy

Traveling between stars
In the glittering night sky of the winter solstice
Ziggy brings her own Earth water

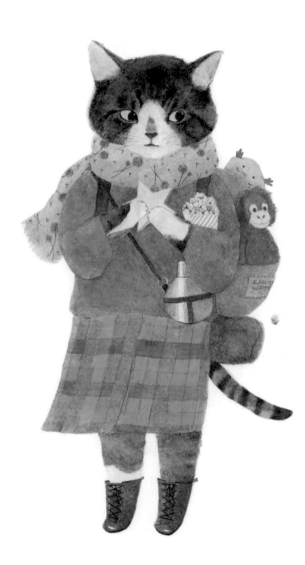

Wahclella

Wally cools her electrified heart
before heading to a big waterfall
Summer sun shines upon

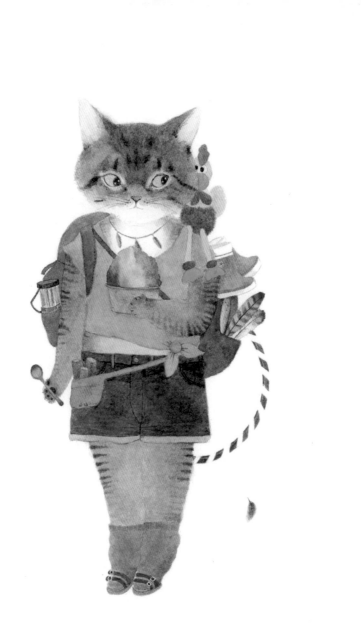

Coolboy

Light-footed Coolboy
keeps walking gracefully
Enjoy the air of fall,
it's calm and quiet

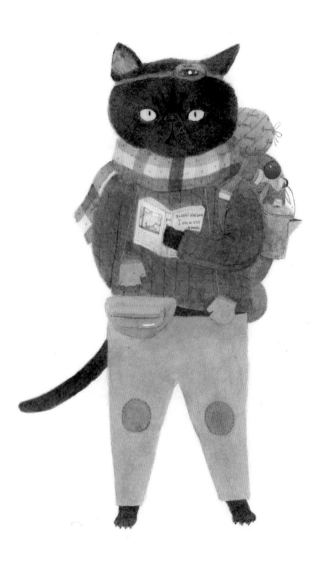

Brett

We continuously resonate and share fun,
Together beyond space and time

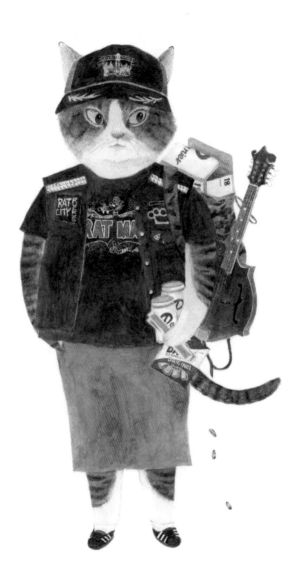

あとがき

私たちはみな唯一無二の輝く魂であり、悠久の旅をつづけています。

これまで、たくさんの人や動物、風景、物語と出会う中、そう思える瞬間が幾度となくありました。そこで湧いてくるインスピレーションを、わたしから視える世界に、ファンタジックなフィルターをかけて体現してみたい。そんな好奇心から、旅する猫、バックパッカーたちのポートレート集、Fur Coats & Backpacks は生まれました。

様々な物語をもち、またとない自分の旅をつづける猫たちを、ふとしたひらめきや衝動、出会いから、自然が赴くままに水彩絵の具で描きつづけて約8年になりました。先々で出会った存在と向き合い、彼らの語りかけてくることや、気風を感じとっていく制作の過程は、まるで静かな星空の下で火を囲んで1匹対1人、ハングアウトするような心地です。描いていると、ある時彼らになんともいえない奥行きを感じ、「誕生」が近くなってきたのが分かる瞬間があります。その時は、自分もまっさらな気持ちになり、やがてあらたな出発をむかえます。

みなさんは今どんな風に吹かれ、どんな旅をしていますか。道中でこの本を手にとってくださり、本当にありがとうございます。旅猫たちがみなさんに、ここで出会えるご縁をとても愛しく思います。それぞれの猫のエネルギー、そして在るがままな風来坊たちが集まったエネルギーをどうぞお楽しみください。これらの毛モコモコ、カラフルなエネルギーが、みなさんの旅路のどこかのタイミングで、一風変わった追い風になれたらうれしいです。

Love,

一桝茉莉
2022年2月22日

Afterword

We are each a unique and shining soul, traveling on our own journey.

As I have met many people, animals, landscapes, and stories, there have been many moments when I have felt this way. From that, a desire grew in me to embody the inspiration that comes from these encounters by applying a fantastic filter to the world as I see it. It was out of this curiosity that *Fur Coats & Backpacks*, a collection of portraits of traveling cats and backpackers, was born.

For about eight years, I have been painting cats with watercolors based on sudden inspirations, impulses, and encounters as they continue their unique journeys with various stories. The process of creating these paintings is like a quiet hangout under the stars, one by one, a travel cat and myself, around a fire. As I draw, there is a moment when I feel an indescribable depth to them, and I can finally see their character fully. At that moment, I feel completely refreshed, and am ready for a new beginning.

So what kind of wind are you blown by and what journey are you on? Thank you very much for picking up this book along the way. It feels like some kind of miracle, the travel cats getting to encounter you at your personal universe-time wherever you are! I hope that you enjoy each individual cat's energy and the wholeness that they create, united as one book.

Let this giant ball of colorful furry energy be your unique tailwind along your journey!

Love,

Mari Ichimasu
2.22.2022

Acknowledgments

To the travel cat family: Characters came from my imagination at the beginning, and over the period of this project, it gradually has led to collaborations with other living souls. Thank you all for sharing your precious stories with me!

Maki	Nike, Stephie
Figaro	Vanessa
Zim	Rhodora, Beck
Wiley, Chowder	Marty, Amanda, Marilyn
Frankie	Erica, Jacob
Eliza	Kuwabata family
Maka	Naoka, Michael
Jackson	
José, Veronica	
Jack	Tiffany
Francis	Kira, Dave
Arnold	Dylan, Xoe
Scoot, Chaos	Lauren
Orion	Emily, Nathan, Brittany, Scott
Spencer	Lauren
Hey! Zeus	Mandie, Nick
Olivia	Loren, Paige
Monster	John, Melissa
Leo	Sara
Joey	Erinn
Daniela	Lacey, Josh, Guiomar
Moonbeam, Leroy	Julia, Steven, Kate, Jesse
Peanut	Brianna, Brody
Moose	Tizzy, Amie

Ziggy	Stacy, Brian
Momo	Caitlin
Wahclella	Eric
Coolboy	Morgan

To my travel cats community: everyone who follows and supports in any way. Each of you means so much to me!

Shout-outs to businesses, events, markets and venues that showcased travel cats:

Chin Music Press, Microcosm Publishing, All City Coffee, The Victory Lounge, PunkRock Flea Market Seattle, Annie's Art and Frames, Nekozane Coffee, Edge of Urge, Roar, Fresh Flours, Short Run, Japanese Animation & Manga Festival, Tractor Tavern's Makers Market, Sodo Flea Market, Georgetown vintage trailer park mall and The Fremont Sunday Flea Market, King Street Makers Market, Herbs House, The Power Plant Seattle, BIPOC Makers Night Market, and Yawata Marche.

To Bruce and the team at Chin Music Press for helping me put the travelers together. Since the beginning of this project, my vision has been to bundle these characters together, and Bruce and the team have been instrumental in making that happen.

To Michio Hoshino for your story and beautiful photographs. You are one of my biggest inspirations.

To my best friend and husband Tony who helped tremendously in all things from top to bottom!

To my daughter Sola for being a fat beam of bright shining light.

To my family in Japan and here in the States for your big love, support, and encouragement!

To all my dear friends. You are individually such big inspirations and the roots of the concept of *Fur Coats and Backpacks*. Thank you for being your ingenious selves.

Miwo for helping me edit my Japanese *atogaki* in the best way! Amie and Olli for your friendship, comfort, and fun photo session!

Sachiko for being my temple and No. 1 cheerleader for anything I do.

To Poop Attack!, Rat City Ruckus, and Rats in the Grass for all the years of pure joy and the magic carpet rides.

To Brett for your huge heart, beautiful songs, and for showing me the power of living in the moment.

And finally, I am forever thankful to my little fur family—Tarou, Mi-chan, Shiro, Kuro, and Tara—for the huge impact they have left on me. Thank you, Coconut, for being here with me now.

About the Artist

Born in Tokyo, raised in Chiba, Japan, Mari Ichimasu is a Seattle-based artist who is passionate about making her inspiration and imagination come to life. She is a mother, a musician, a stop-motion animator, and also an explorer of energy healing. Her intuition and creativity are the core that connects them all.

Photo by Olli Tumelius

東京生まれの千葉育ち。インスピレーション・イマジネーションを形にすることに胸ときめくシアトル在住のアーティスト。
旅猫作家、コマ撮りアニメーター、エネルギーヒーリングの探求、フィドル弾きなど、創造性と直感を軸に活動をつづける。

Website: mariichimasu.com
Instagram: @littleozemari & @furcoatsandbackpacks